Art Can Help

ART CAN HELP

ROBERT ADAMS

YALE UNIVERSITY ART GALLERY • NEW HAVEN

DISTRIBUTED BY YALE UNIVERSITY PRESS • NEW HAVEN AND LONDON

Poetry should be great and unobtrusive, a thing which enters into one's soul, and does not startle it or amaze it with itself but with its subject.

— JOHN KEATS, LETTER, FEBRUARY 3, 1818

Publication made possible by
Eliot Nolen, B.A. 1984, and Timothy P. Bradley, B.A. 1983;
Mary Jo and Ted Shen, B.A. 1966, HON. 2001;
and the Janet and Simeon Braguin Fund.

FIRST PUBLISHED IN 2017 BY THE
Yale University Art Gallery
1111 Chapel Street
P.O. Box 208271
New Haven, CT 06520-8271
artgallery.yale.edu/publications

AND DISTRIBUTED BY
Yale University Press
302 Temple Street
P.O. Box 209040
New Haven, CT 06520-9040
yalebooks.com/art

Tiffany Sprague, Director of Publications and Editorial Services
Proofreader: Zsofia Jilling
Designed and typeset in Adobe Garamond by Katy Homans
Printed at Meridian Printing, East Greenwich, R.I.,
under the supervision of Daniel Frank

ISBN 978-0-300-22924-0
Library of Congress Control Number: 2017938489

10 9 8 7 6 5 4 3 2 1

Contents

Introduction 9

Edward Hopper 12
Edward Hopper 14

Richard Rothman 18
Julia Margaret Cameron
and Abelardo Morell 20
Frank Gohlke 24
Wayne Gudmundson 26

Ken Abbott 30
Edward Ranney 32
Leo Rubinfien 34
Eric Paddock 36
Terri Weifenbach 38
William Wylie 40

Nicholas Nixon 43
Garry Winogrand 46
Mark Ruwedel 48

Judith Joy Ross 50
Cuny Janssen 54
Dorothea Lange 56
Mitch Epstein 58
Emmet Gowin 60
David T. Hanson 62

John Szarkowski 64
William S. Sutton 66
Eugene Buechel 68
Edward S. Curtis 72

Anthony Hernandez 74
Robert Benjamin 77
Mary Peck 80
Dorothea Lange 82

Afterword 84

Introduction

It is the responsibility of artists to pay attention to the world, pleasant or otherwise, and to help us live respectfully in it.

Artists do this by keeping their curiosity and moral sense alive, and by sharing with us their gift for metaphor. Often this means finding similarities between observable fact and inner experience — between birds in a vacant lot, say, and an intuition worthy of Genesis.

More than anything else, beauty is what distinguishes art. Beauty is never less than a mystery, but it has within it a promise.

In this way, art encourages us to gratitude and engagement, and is of both personal and civic consequence.

The subject of a painting or photograph does not by itself make it art, but if there is no important subject matter at all — no clarifying reference out to significant life beyond the frame — then the term increasingly seems to me unearned.

Until fairly recently the word *art* as applied to pictures usually referred not just to representations of the world but to representations that suggested an importance greater than we might otherwise have assumed. Such pictures were said to instruct and delight, which they did by their wholeness and richness. The effect was to reinforce a sense of meaning in life, though not necessarily a belief in a particular ideology or religion, and in this they were a binding cultural achievement.

Unfortunately art of this quality is now little attempted, partly because of disillusionment from a century of war, partly because of

sometimes misplaced faith in the communicative and staying powers of total abstraction, and partly because of the ease with which lesser work can be made and sold. This atrophying away of the genuine article is a misfortune because, in an age of nuclear weapons and over-population and global warming, we need more than ever what art used to provide. Somehow we have to recommit to picture making that is serious. It is impermissible any longer to endorse imitations that distract us or, openly or by implication, ridicule hope. The emptiness of material by Jeff Koons and Damien Hirst, for example, is born of cynicism and predictive of nihilism.

Edward Hopper was, it seems to me, the American painter who most deeply engaged with both what is modern and what is timeless. I try at the beginning of this book to identify a little of his achievement, and then to consider how photographers have also met the test of relevance.

Art Can Help

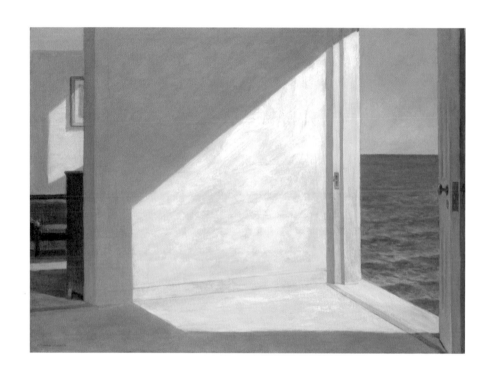

Edward Hopper, *Rooms by the Sea*, 1951

What do we carry forward? My family lived in New Jersey near Manhattan until I was ten, and although I have enjoyed spending my adult life as a photographer in the American West, when we left New Jersey for Wisconsin in 1947 I was homesick.

The only palliative I recall, beyond my parents' sympathy, was the accidental discovery in a magazine of pictures by a person of whom I had never heard but of scenes I recognized. The artist was Edward Hopper and one of the pictures was of a woman sitting in a sunny window in Brooklyn, a scene like that in the apartment belonging to a woman who had cared for my sister and me. Other views resembled those I recalled from the train to Hoboken. There was also a picture inside a second-floor restaurant, one strikingly like the restaurant where my mother and I occasionally had lunch in New York.

The pictures were a comfort but of course none could permanently transport me home. In the months that followed, however, they began to give me something lasting, a realization of the poignancy of light. With it, all places were interesting.

Years later, when I found the other half of Hopper's work, the more rural half, that too was enabling. As a college student I tried to determine how much a person needed to adopt an ironic manner, and Hopper's paintings on Cape Cod and elsewhere in New England demonstrated that it was possible, without sentimentality, to express affection for places that were naturally beautiful. One did not need to be ashamed of having a heart.

Hopper's pictures still teach and please me in ways that seem new. As my memory of my youth fades some, for example, I think I do a little better when conversing with the young if I recall the painting of the usher there at the side of the movie theater, an individual partway between dream and experience. And when I look to my own future I am grateful for Hopper's transcriptions of "sun in an empty room."

First published in *Edward Hopper and Company* (San Francisco: Fraenkel Gallery, 2009)

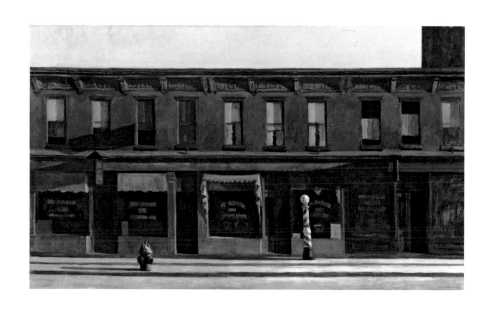

Edward Hopper, *Early Sunday Morning*, 1930

Edward Hopper's *Early Sunday Morning* is a picture upon which to depend. It is affirmative but does not promise happiness. It is calm but acknowledges our failures. It is beautiful but refers to a beauty beyond our making.

If we encounter the picture after we have been to a shopping mall or a housing development, we may see it as less than art, as just cultural history. Our current landscape may seem so much worse than Hopper's that his may strike us as completely removed from the present. If we try by nostalgic reverie to escape into Hopper's picture, however, we are brought up short. His street is in some ways no more easily pleasant than are many of ours.

Nature in Hopper's scene has been almost wholly driven out. The horizon where we might expect to find an organic line has been blocked. Above the architect's straight edge there are no birds, and below it no grass or trees.

The building gives small reason to celebrate the human spirit. There is about the structure some of the dignity of the utilitarian, but refinement has been formulaic — rudimentary pilasters, and a cornice that we know has been extruded for miles. Nothing so gracious as a bay window improves the view from outside or in.

The only escape from this structure, the one mildly comic element in the picture, is a tipped barber pole wrapped in the national colors. What inspiration we can find has to come from the variety with which inhabitants have pulled their shades and curtains, careless of the building's tyranny; in the background, though, we note a high-rise of the kind that will more and more distance us from even such rebellion as this.

In the painting the city is defined by its off-hour quiet. According to Hopper, the title was "tacked on later by someone else," but he let it remain presumably because it was consistent with the evidence.[1] On Sunday we sleep late, and in the picture there are no pedestrians or cars. Nothing moves. Nothing makes a sound.

Most of us would admit to feeling some ambivalence about Sunday. When the mail stops and the telephone rings less often, there is a promise of freedom but also of loneliness. It is a quiet of many levels. We remember that this was the day when God spoke and began the Creation. It was also the day when an angel addressed those who came in grief to the tomb of Jesus, assuring them of a new beginning. It would for centuries be a day marked by church bells, but by Hopper's time there are no spires above the roof.

Why do we treasure this painful scene? How is it even bearable?

Hopper was uneasy when he was asked to talk about his pictures, afraid that he might try to speak in place of them. He had been brought to his vocation by amazement over light, something he experienced independently of words and ideas, so that his desire was to *show* light. It was an intuitive and emotional commitment. "There is," he said characteristically, "a sort of elation about sunlight on the upper part of a house."[2]

He would have agreed, I think, with the cinematographer Raoul Coutard, who observed that "natural light is always perfect." However much Hopper anguished over the displacement of nature, he never abandoned the city because, in addition to the compassion he felt for those who lived there, he reliably found in the city one remaining natural element — sunlight. With it, nothing was irredeemable.

Compare the way his building would have looked in the architect's drawing with the way it looks in the painting. The two representations are in certain respects similar. Hopper, who described his picture as "almost a literal translation of Seventh Avenue," was careful to register major detail, and to do so from a centered point of view that suggests the objectivity of an architect's elevation.[3] Our interest in the building depends, however, on the painter's subjective decision to record this place in the raking light of a particular hour. With that light he adds not only color but a new richness of form: shadow establishes an additional set of curves beneath the edge of the roof,

it divides the upper windows, it unlocks the rectangular grid of the façade by slanting down across it a fresh geometry from protruding signs. The sterilities of the drafting board are enlivened so that we are again interested in the world.

Light explains nothing about meaning, but for Hopper it was the basis of a lifetime's faith.

1. Katharine Kuh, *The Artist's Voice: Talks with Seventeen Artists* (New York: Harper and Row, 1962), 134.
2. Ibid., 140.
3. Ibid., 131.

A reworking of an essay originally published in
Frames of Reference: Looking at American Art, 1900–1950, ed. Beth Venn and Adam D. Weinberg
(New York: Whitney Museum of American Art, 1999)

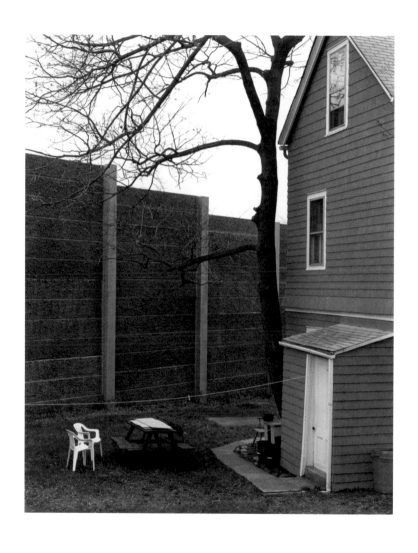

Richard Rothman, *Home with Sound Wall, N.J.*, 1995

Richard Rothman's picture lets us live with our disappointment, just barely. It suggests poet Stephen Berg's description of a cantor's prayer—"inconsolable praise."

The photograph helps us in part exactly because it does acknowledge harrowing fact—it does not lie. The sound wall next to the expressway is savage—dark, not fully effective, and out of human scale. The picnic area, if that is what the table implies we should call it, is desolate: there is not a decorative shrub to be seen, and the mass-produced plastic chairs confirm that little here is particular to individual dreams.

Against the sky, however, there are branches of a tree. They are leafless—we do not know whether it is winter or if the tree is dead from traffic fumes—but the shape is organic. The branches might be visited by living birds.

Few artists care enough about us to risk our alienation by a picture so taut with despair and fragile possibility.

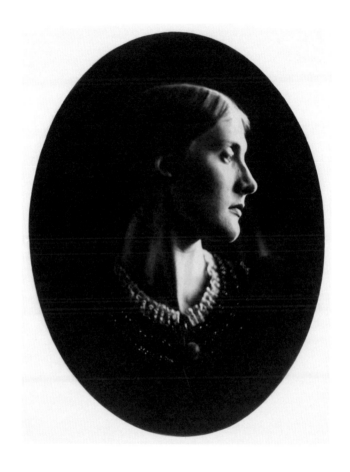

Julia Margaret Cameron, *Julia Jackson*, 1867

Virginia Woolf's mother, Julia Jackson, was photographer Julia Margaret Cameron's niece, and among Cameron's loveliest subjects. Woolf's mother also served as inspiration for the charismatic figure of Mrs. Ramsay in Woolf's novel *To the Lighthouse* (1927).

Perhaps Woolf's family involvement with photography contributed to her belief in the importance of seeing. *To the Lighthouse* is in any case a strikingly visual book, not only because of the author's descriptions in it, which are unforgettable, but also because of the degree to which people in the story change when they truly see. The story is completed, characteristically, when Lily Briscoe, an amateur painter, resolves the composition of a picture with which she has been struggling, and experiences a peace that enables her to accept life's sorrows, particularly transience. As she thinks — they are the last words of the book — "I have had my vision."

The novel is divided into three parts, the second of which is entitled "Time Passes." In it we are informed, almost incidentally, of deaths including that of Mrs. Ramsay, but the focus is on the Ramsay family's empty summer house on the coast of Scotland, and on the way in which, as the seasons come and go, what is outdoors registers indoors: "Now, day after day, light turned, like a flower reflected in water, its sharp image on the wall opposite. . . . So loveliness reigned and stillness." And this, among the most beautiful passages in the novel: "Nothing it seemed could break that image, corrupt that innocence, or disturb the swaying mantle of silence which, week after week, in the empty room, wove into itself the falling cries of birds, ships hooting, the drone and hum of the fields, a dog's bark, a man's shout, and folded them round the house in silence."

Abelardo Morell's camera-obscura view inside an attic, and of the sea brought in, is an emotionally accurate correlative for aspects of "Time Passes," and I always think of it when I read the book. Though Woolf's fictional house is furnished and Morell's attic is not, both writer and photographer show how nature reenters our carefully

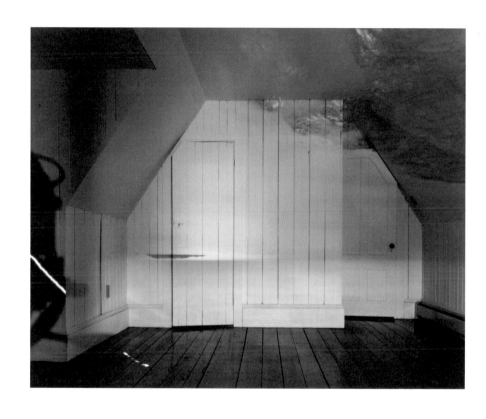

Abelardo Morell, *Camera Obscura: The Sea in Attic*, 1994

protected spaces (in Morell's case by a tiny aperture and long exposure, and rendered upside down), restoring to the temporal the timeless.

One winter and spring I had the good fortune to write at a desk next to an attic window overlooking the Columbia River. It seemed to me then that an entry in Virginia Woolf's diary (referring to her home in the small town of Rodmell) was just right: "Why not stay here forever and ever enjoying this immortal rhythm, in which both eye and soul are at rest?"

Morell may or may not have read *To the Lighthouse*, but he has, in his memorable picture, accurately read life.

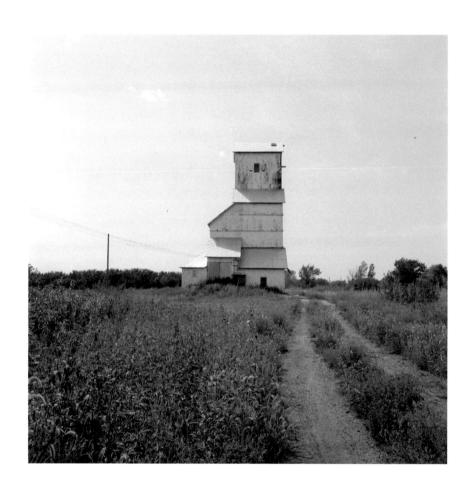

Frank Gohlke, *Abandoned Grain Elevator, Homewood, Kansas*, 1973

When the director of the Yale University Art Gallery, Jock Reynolds, saw this photograph, he remarked to me that the elevator was "a perfect cubist composition." I had not thought of it that way before, and I remain grateful to him for suggesting a new kind of enjoyment to be found in it.

The main reason I love the picture, though, is because I have so often walked near elevators like this one, initially with my father and later with my wife, Kerstin. The experiences were of such happiness—the company, the light, the quiet—that any reminder of them is precious.

Frank Gohlke's photograph appears in his book *Measure of Emptiness* (1992), which records elevators short and tall, made of wood or metal or concrete, and located out by themselves or in town. At first the book seems almost taxonomic in purpose, but as one studies the pictures it becomes apparent that what energizes Gohlke's photography is his hope that we will *like* the elevators. In common with every artist, Gohlke I'm sure felt that his subject was better than any picture he could make of it, but he kept trying because what he really wanted was to convince us to visit places like it. Go there, great pictures urge us.

Gohlke's regard for the world is shared, it seems to me, as comfortably as one would a hymnal.

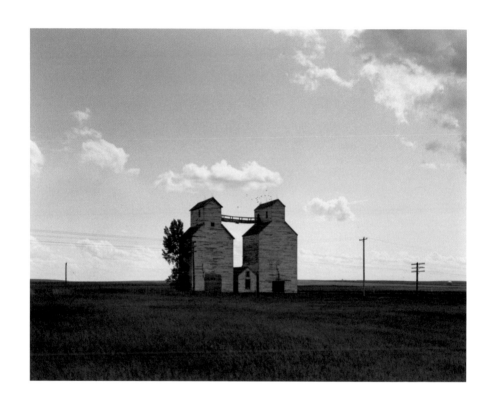

Wayne Gudmundson, *Wheelock, North Dakota*, 1981

Writer Stanley Elkin suggested that all books retell the Old Testament story of Job. Similarly one feels that behind most music there is a struggle with pain. By the time we are adults, the songs we know by heart are often those that acknowledge grief or celebrate release, and the performers we respect are the ones who sing from need—people like Etta James, of whom it was said that she "always hit the notes with the right amount of hurt and hope."

A photographer's subject is his or her score, the given notes on a page. The way the photographer hits those notes—shows the subject—determines whether we will be newly reconciled with it.

Wayne Gudmundson's subject is partly the old grain elevators, which he chooses to photograph in cloud shadow and from a distance, emphasizing in this way their isolation and abandonment. What, he seems to ask, has become of the people, those who endured the winters, raised families, and brought the labor of their best years to this place? And what, particularly, became of the man who kept records in the little office? Did he grow tired and go back east? Did he pause on the catwalk between the buildings, early of a morning, and ask questions of the last star? What did the people achieve for all their struggle?

The other half of Gudmundson's subject is the tree that is the shape of a wing, and the momentary rise of birds just visible above the right-hand elevator. Their flight—a gift of a few seconds that the photographer's life has taught him to celebrate—entirely changes the picture.

Once when I was driving back roads on the plains I heard a disc jockey on a rural station say, after playing some impossibly sad country song (white blues), that he would not "ruin the wonderful gloom of that with a joke." He was being faithful with his listeners. There *is* a gloom that can be wonderful if it is reset by an inspired voice or melody or harmony or instrumentation. A song can sometimes speak right past the words, calling up intuitions that save us.

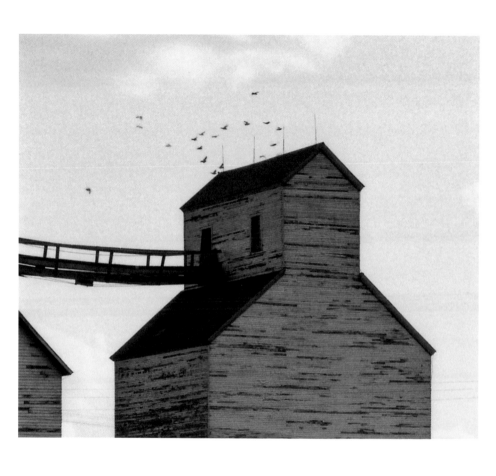

Wayne Gudmundson, *Wheelock, North Dakota,* 1981 (detail)

Gudmundson's tree/wing and the birds—the birds' collective shape, a re-forming pattern that is at every moment perfect—are a melodic answer to the bass line of the deserted buildings with their static darkness.

For many artists, beauty is the voice out of the whirlwind.

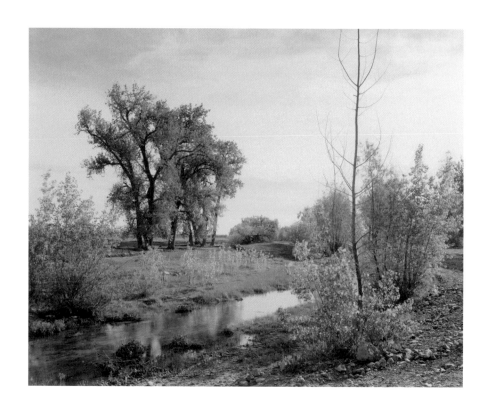

Ken Abbott, *Golf Course under Construction, East of Boulder, Colorado,* 1989

B ecause wilderness is gone, those of us who might have loved it are compelled to review whatever else we can reach that might sustain the spirit. Ken Abbott has sometimes looked along the fringe of suburbanization — down dirt roads soon to be paved, past farmland left fallow in anticipation of development. As here, in a place so delicately beautiful that we can hardly bear to believe that it is about to become a golf course, with all that this change will bring of artificial fertilizers and herbicides and the consumption of irreplaceable water.

Ken's day job, when I got to know him, was as chief photographer for the University of Colorado at Boulder. He is an accomplished portraitist and enjoyed the work, but during his time off he chose to picture landscapes, especially places that some would have seen as impure but that he clearly believed were still in a sense pristine. He often visited them in the spring and early summer, when they looked their green best. I urged him to bring these pictures together in a book, to encourage us, but he never quite wanted to, I think out of the same modesty that allowed him to respond to the places without prejudice.

Leo Rubinfien once encouraged me by writing that I had as a photographer "laid form lightly on life," a compliment I do not always deserve but one I think Ken deserves with photographs like this. Form in a picture is justified by our experience of wholeness (coherence) in life, and if we are to be convincingly reminded by art of such experience then the shape in art has to be believably tentative, as fragile as meaning seems to be in life, as problematic even as the future is for those cottonwood shoots there on the far side of the creek.

First published in the *Yale University Art Gallery Bulletin: Photography at Yale* (2006)

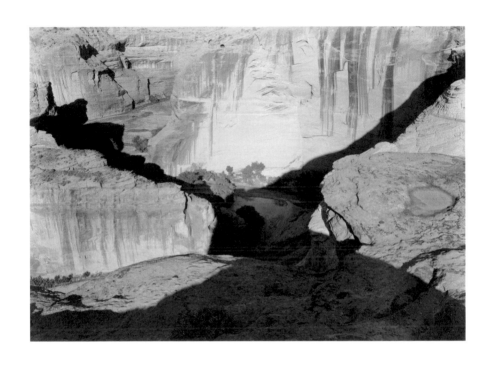

Edward Ranney, *Canyon del Muerto, Arizona,* 1987

Edward Ranney is best known for his photographs of pre-Columbian architecture. He approaches the subject as we suppose the Inca must have approached the designing of many of their buildings, as a sculptor working in and with natural light to reveal form. By his identification with the early artists, he helps us to discover a worldview that was and is reverent and encompassing. He notes, for instance, masonry in which everything fits massively to perfection, crafted to standards in excess of practical need. And he works outward from the structures to find configurations in the natural landscape—of a boulder, say, or a mountain range—that correspond to the built shapes and that must have served as inspiration.

Ed lives in northern New Mexico, about two hundred miles east of Canyon de Chelly (which includes Canyon del Muerto). Many notable photographers have preceded him there, including Timothy O'Sullivan, John Hillers, Edward Curtis, Laura Gilpin, and Ansel Adams. To make a strong new picture at that location is a remarkable achievement.

How did he do it? Probably not by walking the canyon rim with any preconceived notion (if you begin with an idea you're usually beat before you start). To make a photograph of this quality he must have trusted to good fortune and to his eyes, looking with full attention at the water-marked sandstone, the cottonwoods, and the slanting light . . . this specific place and moment. Only from within that focus is it likely that he would have been allowed to see more, a landscape unified by what appears to be part of an *X*, the unnamable.

Perhaps there is also in the picture a suggestion of outstretched arms. I have never asked the photographer if he sees that too, but it might be an appropriate reading by any of us. Art is important when nothing less will suffice, a reconciliation.

First published in the *Yale University Art Gallery Bulletin: Photography at Yale* (2006)

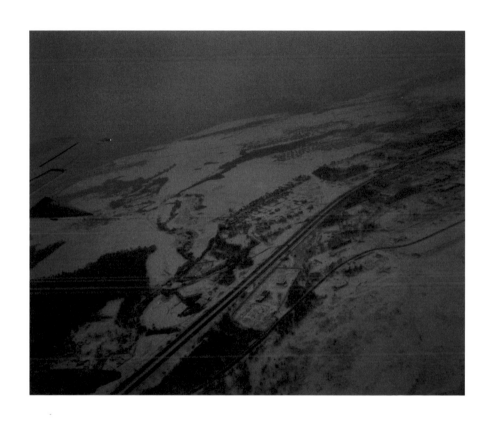

Leo Rubinfien, *Leaving Sheremetyevo, Moscow*, 1992

Equally a photographer and writer, Leo Rubinfien has written an important essay about the work of Diane Arbus in *Art in America* (2005). It is judicious and compassionate. He speaks convincingly from within the predicament of modern urban life.

Of his two picture books [as of 2006] the more startling is *10 Takeoffs 5 Landings* (1994), a collection of aerial photographs that includes this view. Rarely has the subject of the sublime been so convincingly revived. Everything about the book works, including its design: the fifteen pictures of vast, fleeting, and sometimes dissolving scenes are reproduced as bleeds (that is, without borders), a practice that often destroys pictures but that with these keeps us aloft by suggesting the limitless.

What does this glimpse describe, beyond the particular place and moment? What does your life suggest about the picture's significance? There are many landscape pictures focused on roads, and this is one of the best. It is not the only important way to see a road—there are roads at midday, in summer, with friends and family—but most of us do, I think, recognize this blue-cold road for what it is.

Leo travels often by air as he works now to complete a large project. It must on occasion be harrowing, if for no other reason than that he witnessed close up a crash that most of us saw only from farther back. As he sat writing in his apartment only blocks from the World Trade Center, he heard the sound of an airliner inexplicably increasing power and looked up to see it hit.

Photographers tend to be more aware than most of chance. In Leo's case that knowledge is balanced by courage and intelligence.

First published in the *Yale University Art Gallery Bulletin: Photography at Yale* (2006)

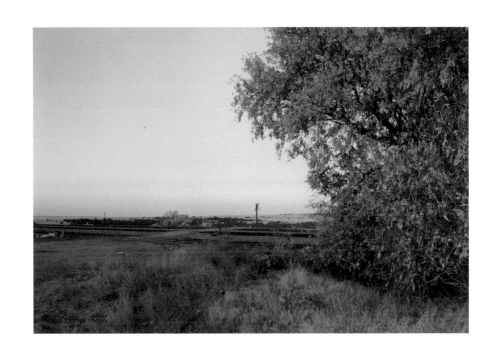

Eric Paddock, *Cedarwood, Colorado*, 1991

Among the impoverishments of contemporary life has been the near extinction of quietly local postcards. Every little town used to sell three or four straight-ahead views of itself, but now only big cities, natural wonders, and resorts seem to generate enough interest to be economical.

Eric Paddock knows what people are missing and has published a collection of postcard-sized views, entitled *Belonging to the West* (1996), that he made along Colorado's byways. It is an accomplishment larger than the small dimensions of the book might suggest.

Stopping in Cedarwood at the end of a fall day, for example, allows us to know a kind of paradise. As the poet Richard Wilbur observed of a related occasion, "The leaves, though little time they have to live, / Were never so unfallen as today."

Yes, it is paradise in a region that some might find unnerving because, at its best, there may often be nobody else there with you. Another poet, William Stafford, described locations like the Cedarwood rail crossing: there is just "space, and the hurt of space after the others are gone." One might be inclined to think that loving such emptiness is part of what defines—or used to define—a Westerner, but of course it also defined Edward Hopper and, to a lesser degree, Charles Burchfield.

I am asked with surprising frequency, "How do you know where to make pictures?" To the extent there is a rule, the answer is that it is usually where you stop long enough. Eric has that discipline, and in consequence the freedom to explore a gift.

First published in the *Yale University Art Gallery Bulletin: Photography at Yale* (2006)

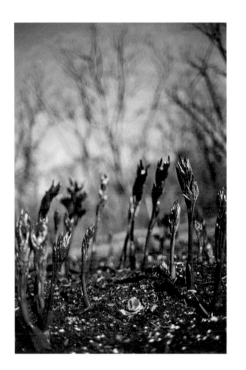 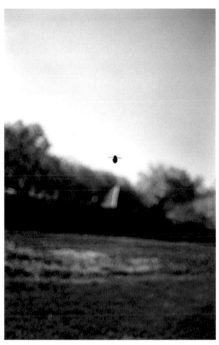

Terri Weifenbach, *XXV, 25 March 1995*, and *II, 21 April 1996*

Making a convincing photograph of a beautiful place is as hard as writing a convincing story about good people. We want to believe, but a lot of evidence stands in the way.

The affirmations that we credit are often those that we can check. We accept as plausible the flowers in Terri Weifenbach's pictures, for instance, because they are the same ones that grow in our gardens.

And with that confirmed, we can be rescued. All winter we have stared at the backyard, and have ended nearly hypnotized by brown. How could we have missed the peony shoots?

Weifenbach's photographs reacquaint us with nature's generosity: cosmos, sunflowers — varieties that hardly need cultivation. In the absence of wilderness we rediscover by them how much is still a gift.

Our dreams are of harmony. George Herbert, the seventeenth-century English poet, described one such vision:

> Sweet day, so cool, so calm, so bright,
> The bridal of the earth and sky.

If the lines now seem antique it is not because we think beautiful days unbelievable, but because we hesitate about the metaphor. And so the manner of the pictures — taken at close distances and from extreme perspectives — is searching.

What does the photographer help us find? First of all, astonishment. Look at the picture of the bee, as aeronautically improbable as an angel.

First published in Terri Weifenbach's *In Your Dreams* (Tucson, Ariz.: Nazraeli Press, 1997)

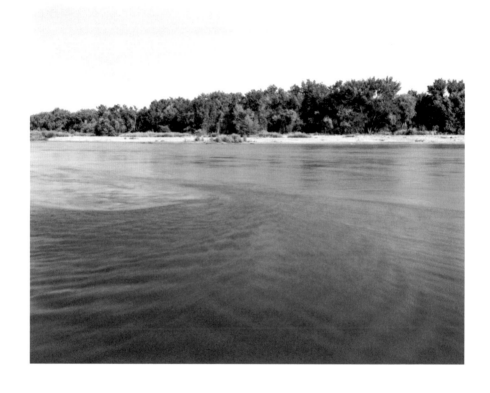

William Wylie, *Cache la Poudre River Flowing into the South Platte River, Colorado*, 1996

Perhaps no other artist except the painter Karl Bodmer has risked so rigorously plain a view of prairie rivers as has William Wylie.

The subject is complex. Loren Eiseley described in *The Immense Journey* (1957) how various and involving might be a summer afternoon's exploration along the Platte. He was a non-swimmer, and had once nearly drowned, but

> the sight of sky and willows and the weaving net of water
> murmuring a little in the shallows on its way to the Gulf
> stirred me, parched as I was with miles of walking, with a
> new idea: I was going to float. I was going to undergo a tre-
> mendous adventure. . . . I lay back in the floating position
> that left my face to the sky, and shoved off. . . . I drifted by
> stranded timber . . . ; I slid over shallows that had buried
> the broken axles of prairie schooners and the mired bones of
> mammoth. I was streaming alive through the hot and work-
> ing ferment of the sun, or oozing secretively through shady
> thickets. I *was* water.[1]

Wylie's picture conveys something of that free, multiple, and redemptive participation.

Taking a photograph with so little structure to keep it afloat must have depended, as did Eiseley's journey, on feeling not only curious but also safe in a new way. Wylie is, unlike Eiseley, a strong swimmer—he can put pictures together that are of sure compositional power—but here he discovered he could just let go, easy in the sustaining adequacy of his subject.

Back home, deprived of the intensity of the actual place, it must have been hard to decide to invest the time needed to make a good print (one with a true sense of the light). Inattentive viewers would, he must have known, think it a worthless scene no matter what he did. And in any case, maybe he had been wrong. What had become

of it, now in two dimensions, the sight that made him forget himself? A picture of a river is not much compared to actually seeing and hearing and touching it.

Photographers have occasionally experimented with adding sound to the exhibition of still pictures—of leaves and birds to landscapes, for example—and although Wylie has never done that (it can seem a kind of cheating), he has made motion pictures that do incorporate sound. Thus far, however, he has always returned to unaugmented still photography, much of it in black and white, possibly judging that full realism comes at the expense of another kind of clarity.

1. Loren Eiseley, *The Immense Journey* (New York: Random House, 1957), 19–20.

Some of the best photographs are both discouraging and encouraging at once. Nicholas Nixon's picture of a calf is of that mixed sort, a cautiously astringent expression of hope.

Like all photographers, Nixon speaks to us in part by what he declines to tell us. In this case the title—"West Springfield, Massachusetts"—forces us to speculate. Are we visiting a family farm? Possibly, but it seems more likely that we are at a county fair, and with that realization we are brought to remember that many large animals there have at best only a few months to live.

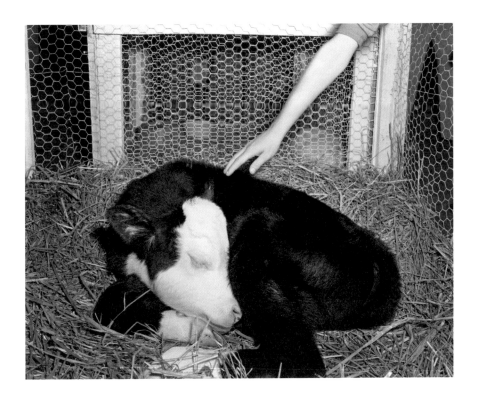

Nicholas Nixon, *West Springfield, Massachusetts,* 1978

43

The photographer also instructively keeps from us the face of the person extending her or his arm. We assume the individual is caring—the touch is so light that the calf does not open its eyes—but the arm is so perfect that it seems almost abstract, almost an ideal. Shouldn't the hand be stroking the animal a little rather than just touching it? Perhaps it is, although the angle of contact does not quite suggest that. In any case what we want is to believe that an actual person, one like you and me, is reaching out impulsively in wonder and with affection. Nixon seems reluctant, however, by not letting us see the expression on the individual's face, to fully confirm the person's humane motives.

If the photographer denies us these clarifications, what does he make plain? To our surprise, he shows us the humanity of the calf's face—the eyelashes, for example, and the suggestion even of a smile. And he makes it encouragingly clear that someone has been attentive, providing a clean, warm bed of straw. And, despite the almost hieratic formality of the arm, there is its beauty.

Beauty implies a promise. I have puzzled over the arm for the thirty years that I have known the picture, and, because no significant artist works unacquainted with the past, I cannot rid myself of the feeling that the picture makes reference to the best-known picture of Creation, the one in the Sistine Chapel showing the hand of God touching the hand of Adam and thus bringing us all to life by completing a kind of current. Here the enlivening current unites the created with the created.

Is there hope? We see from Nixon's picture that this particular calf was not tormented by being confined tightly in a crate in order to turn it into veal. We even see evidence of humane care, and of the possibility of human tenderness. And we know that the photographer saw these things too, and wished to share them with us.

He and we would be naive to claim that the view is of a new world, but perhaps not foolish to see in it a new beginning.

First published in *Photography Changes Everything*, ed. Marvin Heiferman (New York: Aperture and the Smithsonian Institution, 2012)

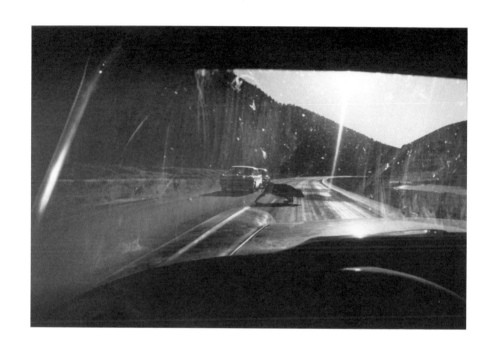

Garry Winogrand, *Wyoming*, 1964

In Garry Winogrand's well-known pictures of zoo animals, part of what strikes us is the animals' otherness. The same is not true here, where we share a creature's pain.

Incidents like this happen, at a guess, a dozen times a day in the American West (my own parents hit a steer while driving at night near Vernal, Utah). Perhaps the accident in Winogrand's picture is not technically any one person's fault, and maybe the car was not too seriously damaged, and maybe it was not even our car. Still, because the animal probably has to be destroyed, it ruins the day, even though we know that the steer would eventually have gone to a feed lot and then to slaughter.

There are many things that discourage me, but I am encouraged by the persistence of conscience. Winogrand's photograph keeps us alive, overruling all assurances from behaviorists that we are never guilty.

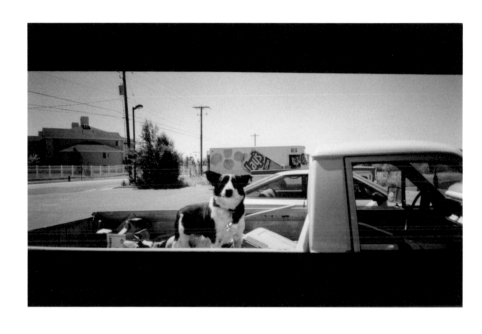

Mark Ruwedel, *Syracuse, Utah*, 1998

Mark Ruwedel is deservedly known as a fine landscapist, but he is also a fine dog photographer. I have several dog postcards from him, of which this is my favorite.

As Mark tells it, he had just parked in front of a little grocery when another pickup drove in next to his. The driver got out, told the dog in the back to stay, and went inside; shortly afterward the dog jumped out, went to the door of the grocery and looked in, walked across the street to make the acquaintance of people at a gas station, followed his curiosity down the block, and then returned and jumped in seconds before his master came out, said something approving, and drove away.

Is the picture art? Maybe not, but with the story it's a pretty good start, as laughter sometimes is. Humorist James Thurber would have loved it. Buster Keaton too.

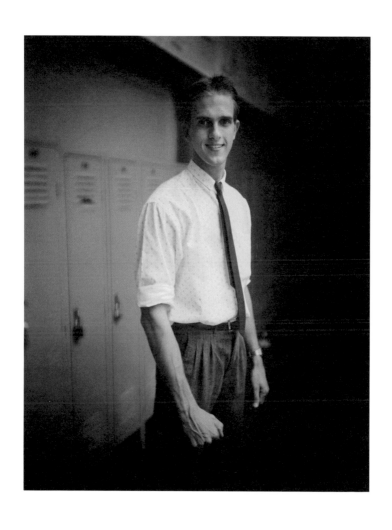

Judith Joy Ross, *First-Year Teacher*, 1992

If I were young and my parents sensibly told me that they hoped I would be almost anything but a photographer, I think I would show them Judith Joy Ross's *Portraits of the Hazleton Public Schools* (Yale University Art Gallery, 2006). I would tell them that this is the sort of thing that is worth a life. And I am quite sure I would convince them, because the only way to resist the pictures is to have a heart made entirely of numbers.

Why are the photographs unforgettable? In part because they truthfully picture the vulnerability of children. Pain is a burden we share throughout life, and many of the portraits record subtle evidence of early encounters with it. We never stop trying to understand.

The full significance of pictures is determined by the needs of specific viewers, however, and for my part now, as an American whose country seems in moral collapse—this country having endorsed war and torture as instruments of empire—I find myself focused upon related but slightly different matters: if education is our only hope, the photographs usefully remind us of the basis for that hope—open, innocent children, and caring, if tired, adults.

Many of the youngest students in the pictures are beautiful, almost as if shown us by Fra Angelico. The gift of their radiance is unarguable and valuable beyond estimate.

As the students grow older, however, they more and more betray a distracted sadness, responding, I'm sure, to the general nature of life, but also perhaps to the sterile new building in which they study. Or perhaps they find in the building something related to the construction of our society as a whole.

The teachers are, I think, the center of the book. The first-year instructor, who is not much older than the twelfth graders, seems to have found what we would wish for the students: recovery and engagement. The older faculty members are heroic in their patience; they have a working-class gravitas that the photographer respects with her spare compositions.

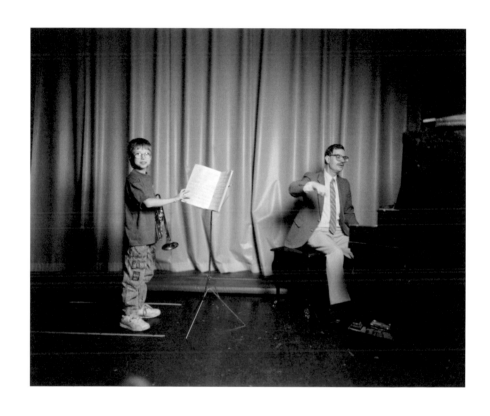

Judith Joy Ross, *Ryan Boyle and Mr. Brubaker*, 1993

This is not to say that Ross is all solemnity. She brings to school a lively sense of humor, and it couldn't be otherwise. Imagine setting up a big wooden camera on a tripod and then covering the contraption and yourself under a black cloth while in the midst of gleeful barbarians like those in *Victoria Sherock and friends fooling around* (a wonderful caption).

The picture I admire most is of Mr. Brubaker at the piano with his trumpet student Ryan. Is there anyone more comically, more courageously of another world than a grade-school music teacher, especially a band teacher? What did this man once hear, probably before he realized he would teach, that brought him to study music? And what might the boy be brought to hear, standing there in baggy pants and oversized tennis shoes, with his horn so close to Mr. Brubaker that it seems likely to blast the good man right off his bench, deafened?

The pictures are an artistic achievement of the first rank, not least for their transparency. We do not need to talk about how they work—about aesthetics and technique—because they work so perfectly. These are photographs wholly, flawlessly, in the service of their subjects.

The pictures are helpful both for the evident faith inherent in the artist's seamless construction and because they awaken us from indifference as our country moves toward a fascist state. I think, for example, of the fact that currently almost none of the people I know who have school-age children enroll them in public schools. Their reasons for this are ones with which I sympathize, but collectively the implications of their decisions are grave. When one sets Ross's book down, one thinks a long while about the pictures, about schools and children, and about the future.

First published in *Aperture* (Fall 2006)

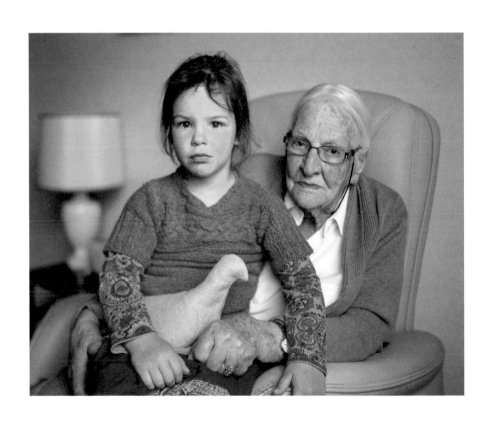

Cuny Janssen, *Bussum, the Netherlands 2015*

Home and family are supremely precious. Without them it is difficult to find meaning in life, and thereby the will to engage an often pitiless world.

Cuny Janssen lives in the Netherlands. Her subjects in this picture are her younger daughter, Ree, whose eyes are from Rembrandt, and Ree's grandmother, whose entire face recalls much of what is beautiful in Dutch portraiture.

Over the years the photographer has traveled beyond Holland to picture children in places as diverse as Macedonia, Iran, South Africa, India, the United States, and Italy. In these locations she has found young people who are strikingly individual but who share, no matter their circumstances, a perfection that suggests a common origin.

Janssen has said that she hopes photographers might again join together as they did in 1955 on the occasion of Edward Steichen's exhibition *The Family of Man*. There are things about that show that one would change now, but its enormous achievement was to remind viewers, who had recently suffered through a world war and who confronted the possibility of another, that people are united by more than divides them. It documented an urgent, observable basis for peace.

Despite this photograph's beauty, it has within it a current of anxiety. One notices particularly the hands. Ree has brought with her a dove, though as her mother notes in an accompanying letter, the city of Brussels, where terrorists recently contrived an attack on Paris, is only two hours from their home.

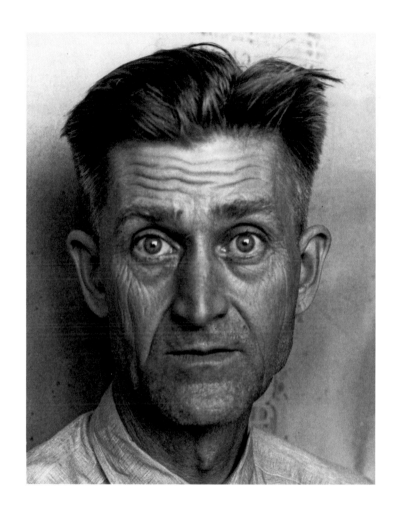

Dorothea Lange, *J. R. Butler, President of the Southern Tenant Farmers' Union, Memphis, Tennessee,* 1938

My grandfather on my father's side was for some years a tenant farmer in Missouri. Dorothea Lange's picture first attracted my attention as it explained my father's thrift.

More broadly, the photograph is about cost. There is in the man's eyes an understanding not unlike that in the eyes of those photographed awaiting execution by the Khmer Rouge. Our country, too, has within it a violence—usually slower and more hidden, but overwhelming.

My grandfather died early, worn out.

Charlie Chaplin, who was at times completely serious, remarked that just as Carl von Clausewitz said that war is the natural extension of diplomacy, so murder is the logical extension of capitalism.

Nonetheless, the poet William Stafford was also correct: "Here's how to count the people ready to do right: 'One.' 'One.' 'One.'"

Photography tends to be less pure than painting, probably because it comes so directly from life. A photo can be art, where the goal is calm (stasis), or journalism with its commitment to fact, or propaganda designed to stir us, or it can be a mixture. Lange believed, on the evidence, that there are times when art alone is impermissible.

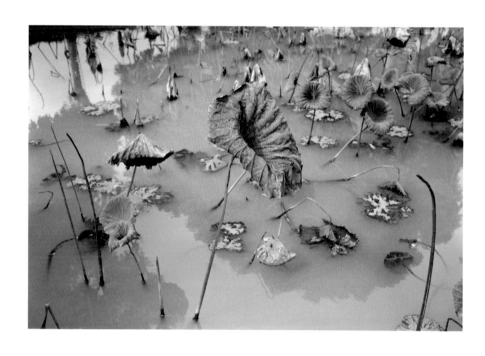

Mitch Epstein, *Lotus Pond, Ha Son Binh Province, Vietnam*, 1993

It is frequently said that the Vietnam War was second only to the American Civil War in its corrosive effect on the United States. Certainly the Vietnam War's legacy of disillusionment and self-loathing continues to this day, often unacknowledged and therefore unaddressed.

Mitch Epstein's photo essay *Vietnam: A Book of Changes*, published in 1997, concerns what followed the war in that country. As the title implies, it is not entirely bleak, but the colors are often acid, there are few smiles, and the feeling is claustrophobic, as in views within a gutted American tank and inside decaying French colonial rooms.

At the conclusion of the brief text, we are told that upon being given some cans of Coke and beer, children "made up a song about sugar cane, and sang the simple verse over and over again: 'Some cane blessed with sweetness, some cane blessed with bitterness.'"

Put in the terms of this picture, the lotus leaves, shown a military-issue green-gray, appear paralyzed in what looks to be toxic muck. It seems a record, both literal and figurative, of the defoliant we applied and that will continue to poison generations.

As California's Governor Jerry Brown, a Buddhist, has observed, "If there were a true religious spirit, we would have to radically change the way politics is conducted."[1]

1. "Politics and Prayer: Jerry Brown Talks with Les Levine," *Tricycle* (Winter 1992): 76.

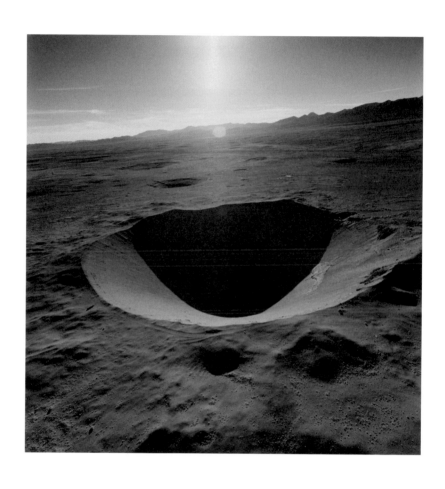

Emmet Gowin, *Sedan Crater, Northern End of Yucca Flat, Nevada Test Site*, 1996

This lunar picture, and others taken by Emmet Gowin above the Nevada test range, remind me of an incident I witnessed years ago in a barbershop. The peaceful sound of hair clippers and sports talk had lulled waiting customers into vacancy when suddenly an old man said with anger that he knew there would be a nuclear war within fifty years. He may, I now speculate, have been a retiree from the nearby Rocky Flats Nuclear Weapons Plant, but his breach of barbershop decorum — no politics, no religion — was so absolute that it drew no response, and in a minute or two the soporific drone of the shop returned. I think that most of us believed, whatever our views on the rights and wrongs of nuclear weapons, that he was probably mentally ill.

It was not until recently, when I read Eric Schlosser's *Command and Control* (2013), about the history of our development and deployment of nuclear weapons, that I realized how rational the man may have been.

Gowin made this ominous picture just a few years before going to Panama and photographing his wife amid leaves and colorful moths, a lovely testament of close-in wonder and affection. Taken together the two sets of pictures test one's spirit almost to the limit. As the Elizabethan song asks, "What is beauty but a breath?" And yet . . .

Like many artists, Gowin feels a personal responsibility. "What we all want in our lives," he has written, is "a way to put ourselves into accord with the mystery out of which we came and into which we will return."[1]

1. Emmet Gowin, *Mariposas Nocturnas: Edith in Panama* (New York: Pace/MacGill Gallery, 2006), 56.

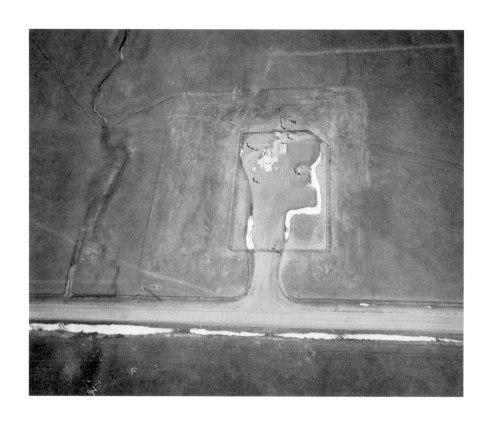

David T. Hanson, *Malmstrom Air Force Missile Site #Lima-4, 341st Strategic Missile Wing, Judith Gap, Montana*, 1985

In the summer, intercontinental ballistic missile silos can seem almost pastoral. There are meadowlarks and sunflowers, and cattle sometimes graze right up to the fence.

At another season, however, David Hanson saw a fist or a skull, and the bleaching of winter.

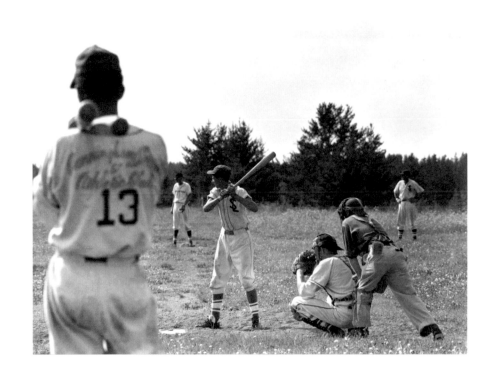

John Szarkowski, *Baseball Game, Sturgeon Lake*, mid-1950s

Photographer Henri Cartier-Bresson spoke famously of pictures that capture a "decisive moment." John Szarkowski records a decisive moment about to happen: the batter will or will not silence scoffers talking it up in the infield.

Each player adopts a posture traceable to long custom. The easy contrapposto stance of number thirteen, for instance, warns the opposition that he can send the ball into the trees.

The game is serious—they have uniforms—but the grass in the outfield is shaggy, and if there are onlookers we don't see them. It seems a game strictly for itself, on its own compelling merits.

What does the picture mean? I think Szarkowski intended it to mean—if that is the right word—that America is, in addition to its wider aspirations, this particular event in Sturgeon Lake, Minnesota.

Jake Shivery has written, with wit that would have pleased Szarkowski, about a time when he got a good picture because of a "decisive morning." Here, it was that sort of afternoon.

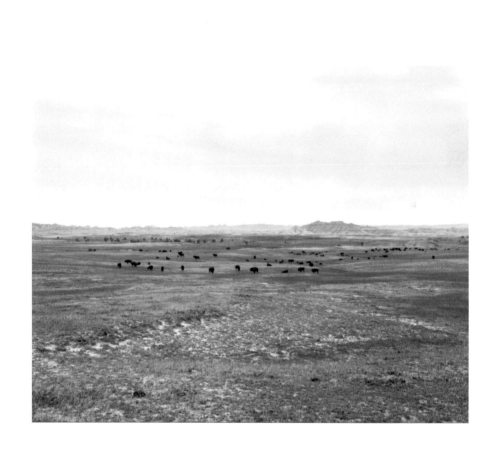

William S. Sutton, *Bison. Badlands National Park. South Dakota. 1985*

It has been suggested by Frank and Deborah Popper that we should create a vast nature preserve in the Great Plains by returning 139,000 square miles (covering ten states) to native prairie and reintroducing the American bison.[1] I vacillate between intending somehow to try to help this happen, and shrinking from the effort, recalling poet William Stafford's line about being addicted to "the bitter habit of the forlorn cause."

William Sutton's dreamlike view (the more so for being in black and white), with the animals seeming almost to float in an equilibrium of land and sky, suggests the hope cherished earlier by Indians and expressed in their Ghost Dances at the end of the nineteenth century, when the West as open space neared its disappearance.

The ideal captured in the photograph is both a promise and an obligation. It will, in some way at some place at some time, come about. But with our help it could happen sooner and maybe even better, made possible by a new deference.

1. Deborah Epstein Popper and Frank J. Popper, "Great Plains: From Dust to Dust," *Planning* (December 1987): 12–18.

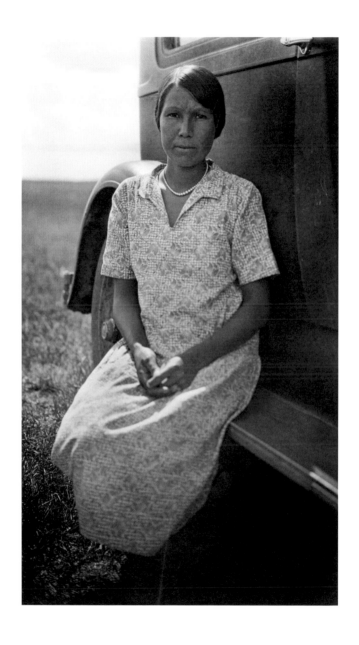

Eugene Buechel, S.J., *John Cordier's Big Girl*, 1932

These photographs were taken by a gifted amateur. They remind me that the medium has historically been especially open to visionaries at the margin.

I am also pleased by the fact that prints from the negatives have been made by college students (at Grossmont College, under the direction of David Wing). Higher education can many times seem removed from life, but in this case I know that the students, looking down at the photographs as they fixed and washed them, learned something of the seriousness of life — its adversities and blessings.

The adversities are unmistakable. Growing up on the Rosebud and Pine Ridge reservations in the 1930s was harsh: one cannot help speculating that the thin, bent legs of the younger girl resulted from malnutrition or inadequate medical care. Additionally, both subjects have been dispossessed. Nona Sharp Fish's hair has been cropped, as probably Ms. Cordier's has too; all Native American children who attended boarding schools were once forced to suffer this as a way to break their bond with home. In its place they were introduced to a different material culture, at once tempting but in some respects empty, and indoctrinated in an alien religion. Even such consolations as remained on the reservations were for many eventually to be exchanged for city life. We have the feeling, looking at Ms. Cordier there on the running board of the car, that she is about to leave.

We share with her an unspoken grief, and are afraid. Native Americans have of course a different history than do most of us who will study the picture, but everyone who loved a more open landscape is disinherited.

If these are some of the hard truths about which the photographs reinstruct us, how might they also argue for promise and the importance of reengagement? That is, after all, the goal toward which art is duty bound to encourage us.

Perhaps most obviously, the subjects are people about whom we naturally care. How lovely they are: even their clothing, despite

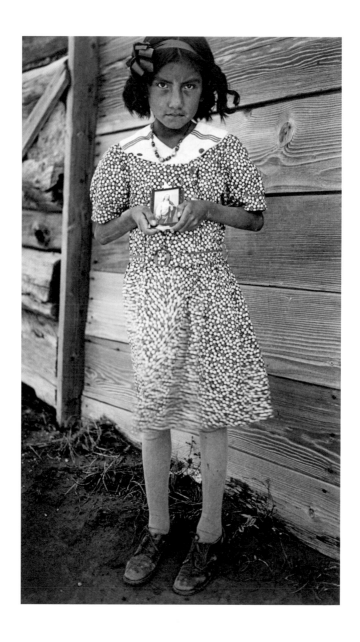

Eugene Buechel, S.J., *Nona Sharp Fish on Day of First Communion*, 1936

poverty, is handsome. And how admirable is their composure. Their direct gaze, and Ms. Cordier's folded hands, testify to a courage that few of the rest of us ever attain.

Moreover, the pictures are suffused with transforming light, making even the grain of wooden boards astonishing. And when sunlight strikes Ms. Cordier's hair and hands and dress, we see that, even if she leaves the known world, she and we are not lost.

We also celebrate in these pictures their record of form, of a moment when every element, good and bad, came together in the camera finder. We take heart from form in art because in the last analysis it is a convincing metaphor for wholeness in life. Even when life seems broken.

A reworking of a statement that accompanied the donation of the pictures to the San Francisco Museum of Modern Art, 2001

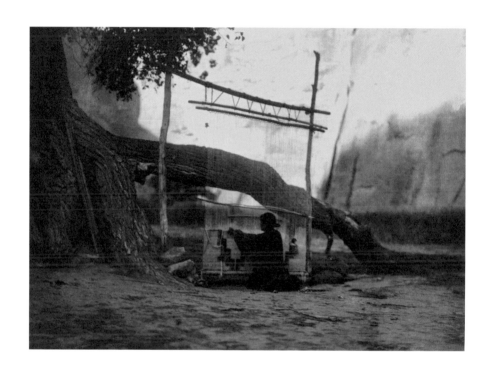

Edward S. Curtis, *The Blanket Weaver, Navajo*, 1904

Wendell Berry remarked to an interviewer that he measured visual art by whether he would want to live with it in his home.[1] I admire the rigor of that, and its basic sense, but I have to admit that I have found the standard beyond me. It doesn't allow refuge. Goya's *Asmodea*, for example, with its nightmare figures in the sky, is accurate about some aspects of our experience, but I could not survive confronting the picture at unguarded moments.

Edward Curtis's picture of a Navajo weaver is one that for years I have kept above my desk. It is the very image of home. The house, as one might think of the canyon, is made of the warmth of light and the mercy of shadow. Inside it, the root of the great cottonwood appears woven into an emerging fabric of understanding and response.

Canyon de Chelly, the probable location of the picture, is even today a sanctuary. Beyond the canyon, however, there has developed a world of crowding, brief attention, and compulsive travel.

Anthropologists are correct to note that in some instances Curtis misrepresented literal fact, but this misses the central point of his effort, which was to picture what he most admired in Native American culture — an awareness of the sacred.

1. Marilyn Berlin Snell, "The Art of Place: Interview with Wendell Berry," in *Conversations with Wendell Berry*, ed. Morris Allen Grubbs (Jackson: University Press of Mississippi, 2007), 54.

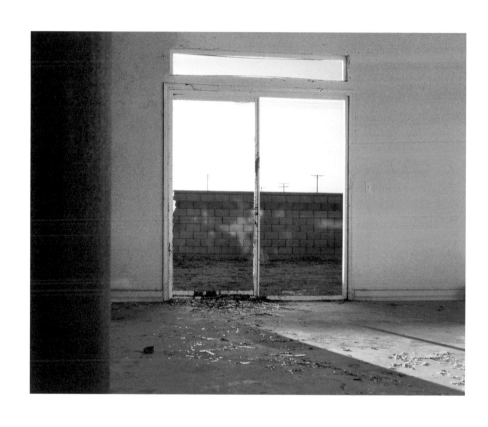

Anthony Hernandez, *Discarded #50*, 2014

Alfred Stieglitz said that "all true things are equal to one another," and in that he spoke for most artists. They are convinced, despite having to sort through daily practicalities by triage, that everything is of immeasurable consequence.

For Anthony Hernandez, everything really means everything—a chair made of broken drywall, a fishing place where one might not want to eat the catch, a platinum-colored wig . . . And everything means everyone—a woman with flowers in her hair, a man with a boxer's broken face, an office worker alone at noon with a book . . .

Why, on the evidence of the pictures, is everything important?

First, because we are part of it all—our part being to be blessed with language that enables us to stand outside ourselves and to make choices. We can choose to be caring. Hernandez's early and middle work, particularly *Landscapes for the Homeless* (one reads the "for" as accusatory) and *Shooting Sites*, reflect as he has said his experience as a medic in Vietnam. The pictures come out of anguish and they ask for change. As do by implication later photographs of the negligent wealthy on Rodeo Drive (the case there is made with singular restraint and pity). At stake is human suffering, much of it of a private, urban kind. At the bus stops we see again a signature hurt in America—isolation, vulnerability—but with new force. L.A. streets have never seemed more directionless.

Hernandez's pictures also argue for consequence because the world he shows deserves reverence—it has a beautiful purity that endures in spite of our carelessness. We see this especially in later, minimalist pictures like *Discarded #50*, which track a saving journey of spirit. There are parallels, I think, with the abstract work of painters like Mark Rothko, who spoke of his pictures as based in "religious experience," and Agnes Martin, who said she wanted to convey "the perfection underlying life." "When your eyes are open," she wrote, "you see beauty in anything."

It is especially telling that in recent photographs Hernandez has included more and more sky, potentially a minimalist's paradise—everything in nothing. Saying such things, however, brings me to realize again that words are not much good around pictures. As Rothko noted, "Silence is so accurate."

Years ago Tony sent, without explanation, two sticks that he had trimmed, wiped with thin paint, and fastened, using baling wire, into a cross. I still have it on the wall next to my desk, and it evokes, as he knew it would, memorials that I have seen in early Hispanic cemeteries along the Rio Grande Valley—places of hard, dry sadness, but also of promise. The only flowers were plastic, but they and everything else were important.

A reworking of an essay originally published in *Anthony Hernandez*, exh. cat. (San Francisco: San Francisco Museum of Modern Art, 2016)

Robert Benjamin places us where we can rest a hand on the irregularly bent wall of the stock tank. In the distance, the rain is coming our way and the light is about to change. There is, just now, no place on earth exactly like this one.

The photograph is memorable, too, because of the boy, the photographer's son, Walker. The picture is built on their trust in each other's affection.

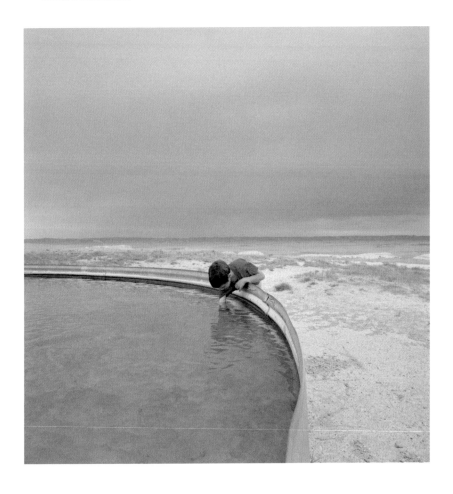

Robert Benjamin, *Walker at Pawnee National Grassland*, 1996

And the scene holds us because it implies something beyond itself. The surface of the water is a mirror not only of the sky but also of an unaccountable peace and benevolence. Perhaps like John Steuart Curry's painting of people around a stock tank in Kansas, the picture is of a baptism, although one independent of theology.

All of these elements—geography, autobiography, metaphor—are brought together by the photographer's self-surrender. Though the picture is achieved with the help of choices he makes (his division of the photograph in half, for instance), his goal seems to be not self-expression but the simple recording of the sufficiency of what is. It is not an easy thing to attempt. The cattle industry has scarred thousands of square miles—some of the problem is there in the picture—and the destruction hurts, but even while he acknowledges what is wrong he seems to repeat an old word, *Amen*, sometimes translated as "may it be so."

Benjamin's picture was taken years ago and only recently printed. In the interim, the plains have been extensively damaged by the oil and gas industry, and it is more than possible that the place the photographer celebrates is now beyond finding. Nonetheless, for reasons that define art but escape full analysis, the picture remains encouraging. Its maker's vision helps us to accept the consequences of our folly and to try to do better.

When I think about those I know who make pictures of this quality, I remember lines by Stephen Spender. The landscape the poet describes is a little different, but his gratitude is mine:

> See how these names are feted by the waving grass
> And by the streamers of white cloud
> And whispers of wind in the listening sky.
> The names of those who in their lives fought for life,

Who wore at their hearts the fire's centre.
Born of the sun, they travelled a short while towards the sun,
And left the vivid air signed with their honour.

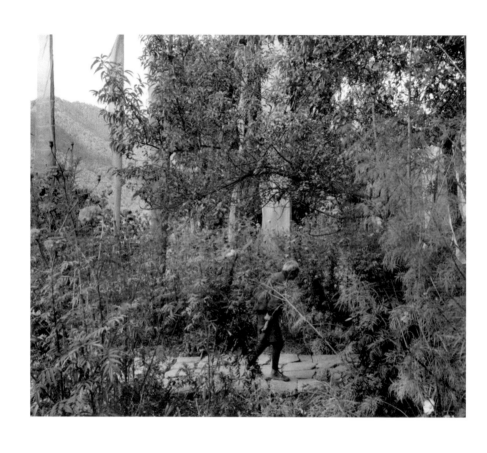

Mary Peck, *Kyichu Temple, Paro, Bhutan*, 1999

Mary Peck served as photographer Laura Gilpin's darkroom assistant and gardener. She has Gilpin's command of craft, her strength of commitment, and her delicacy of perception. Above all she has a similar gift for picturing the relation of spirit—hers and others'—to landscape.

In order to afford to travel to Bhutan, Peck lived austerely in the United States, and in Bhutan she did the same. If the word *professional* refers not to making money but to the gift and discipline to profess what is important, she has earned the right to the term.

Early in her photographic work she went to New York City, as do most artists trying to survive by finding gallery representation, but she quickly sensed disinterest and came back west. When apologists for the contemporary art establishment admit that much of the so-called art world is false, but argue that it is relatively harmless, I think of many such stories by others. Though as the critic and historian Ingrid Rowland has written in reference to some things in major museums that are currently fashionable but better forgotten, "Eventually, the relative quality of . . . recent holdings will sort itself out."

The wisdom of that is undeniable, but for us to wait passively for the sorting out to happen is a costly choice, not only for artists but for society in general. Work like Mary Peck's reflects a vision of wholeness, an understanding upon which sustaining art depends and without which we as a people are ever more prey to the seductions of novelty and propaganda.

Peck believes, on the evidence, in something that the f/64 photographer Consuelo Kanaga wrote: "If I could make one true, quiet photograph, I would much prefer it to having a lot of answers."[1]

1. Margaretta K. Mitchell, *Recollections: Ten Women of Photography* (New York: Viking, 1960), 160.

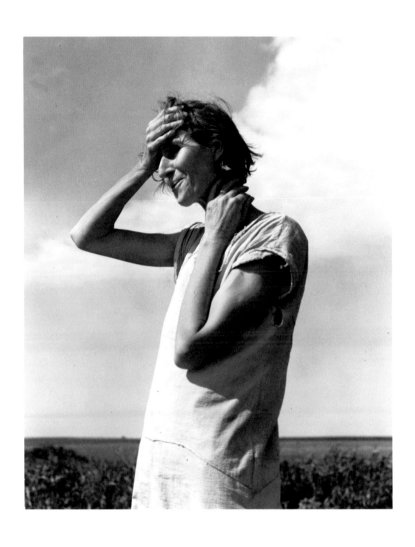

Dorothea Lange, *Woman of the High Plains, Texas Panhandle*, 1938

Dorothea Lange noted in her journal that the woman, who appears to be relatively young, said, "If you die you're dead. That's all." Without in any way denying the truth of that, and in fact building on it, the photographer shows something more, something for which there are only inadequate words. The best writers have nonetheless tried to say what it is, and Marilynne Robinson is among them, speaking in the novel *Lila* of "weariness . . . as beautiful as light."

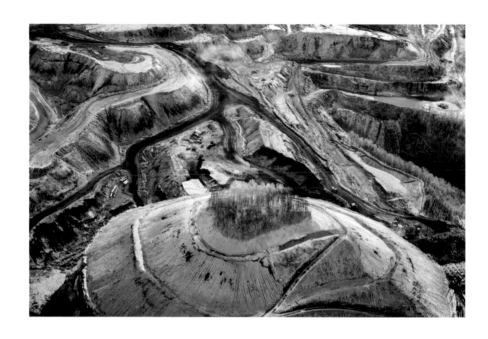

Shawn Poynter, *The Jarell Cemetery on Montcoal Mountain in West Virginia*, 2012

Afterword

We are in important ways the sum of the places we have walked. And because the terrain seems so contradictory—peaceful here and terrifying there—the farther we walk the less we are inclined to claim we know. I am in my late seventies.

What will this day bring? In a week we may not remember, or we may never forget. On the Northwest coast where I live, for example, there have been magnitude 9.0 earthquakes every three to five hundred years; the most recent occurred in the year 1700.

Where in time are we now?

Not long ago I came upon an aerial photograph of coal being mined in West Virginia by mountaintop removal. Everything in view was torn apart except a small community cemetery.

Where in time are we now?

Anne Porter's lines are honest: "Good-bye sweet-whistling quail / Milkweed and Queen-Anne's-lace . . . the bulldozers have come."[1]

Where in time are we now?

I think of what is recorded in my own work. As one critic observed, "Gradually it becomes clear that the horizon promises nothing."

I want somehow to contest that, but when I look out from my living room window I see not only the westernmost campsites of Lewis and Clark but ridge after ridge of clearcuts. It is, as a book describing American forest practices is titled, "strangely like war." A war upon ourselves.

It is difficult to believe that we have a future.

My own convictions are these:

1. Human beings are tragic. Evidence includes the history of my own country, the United States. How often we have adopted Davy Crockett's motto, "Be always sure you're right— then go ahead."

2. Partly as a result, "in life there is much to endure and little to enjoy." The words are Samuel Johnson's, who justified burdening us with them by noting that "the mind can only repose on the stability of truth." He would have agreed with the writer Jane Hirshfield: "One thing no poet does is look away."

3. There is, however, consolation to be found in the caring of family and friends, in the beauty of some of the natural world, in some of the achievements of civilization, in the not infrequent kindness of those known only a little or not at all, in the reassurance of some stories, in the inexplicable rightness of some music, and in the witness of some pictures. The latter testifies, at its best, to the poise of Mont Sainte-Victoire, to the quiet of Seventh Avenue in New York on Sunday morning, and to the promise of the Annunciation as envisioned by Donatello and others.

When he was asked by Calvin Tomkins of the *New Yorker* what he thought art was, John Baldessari replied, "Not a clue. Not . . . a . . . clue."[2] That inability to suggest even a tentative beginning for a definition is characteristic of majority opinion now, but it cannot go on much longer. It invites trivialities, and the world desperately needs better. Threatened as we are by the consequences of pride and selfishness, art cannot be just anything at all.

Art has never been easy. It happens only when a composer like Olivier Messiaen listens so attentively to birds that he can incorporate their voices into his music. It happens only when a novelist like

Marilynne Robinson is so disciplined of spirit that she can wait twenty-four years after publishing a highly regarded first novel to release a second. It happens only when a photographer like Dorothea Lange wills herself past exhaustion to retrace twenty miles of road on the suspicion that she should have turned off at an inconspicuous sign, one that eventually led her to a migrant mother and her children, homeless at the edge of a pea field.

Art is not just anything.

Author Wendell Berry has spoken accurately about what art is: "The best art," he told an interviewer, "involves a complex giving of honor. It gives honor to the materials that are being used in the work, therefore giving honor to God; it gives honor to the people for whom the art is made; and it gives honor to the maker, the responsible worker. In that desire to give honor, the artist takes on the obligation to be responsibly connected both to the human community and to nature."[3]

Meeting that obligation is not experienced as a burden, and it is not necessarily solemn. There is a documentary film that you will enjoy, if you haven't already, called *The Quince Tree Sun* (or *Dream of Light*), about the Spanish painter Antonio López García and his attempt to depict a quince tree outside his home in Madrid. The film records three months of intense, problematic work—the tree keeps changing shape under the weight of its maturing fruit—but there is throughout a sense of joy and privileged focus. Twice a colleague from art school days comes by, and, though García goes right on painting most of the time, the two men carry on a rambling conversation rich with memory and humor and ardent commitment. At one point they even harmonize a little on an old song that they both like, and at another García remarks, half joking in reference to his attempted picture, "This would be funny if it weren't so serious." Any artist might say that by way of acknowledging why he or she is grateful—thankful

for a vocation, for friendship, for even partial victories, and for what García says is the best part of it all, "being close to the tree."

Notwithstanding times like that, one cannot help dreaming of a world where the odds of success are better. García ends with only a fragment—an unfinished painting, an impressive fragment, but also a lesson in humility.

Two lines by the poet Czeslaw Milosz remind me of how strict the terms of our enlistment are: "Put on the very edge of the abyss a table, / And on the table a glass, a pitcher, and two apples."[4] He is speaking in general of how we should each try to live, but the metaphor seems derived from the painting of still lifes, except that in this case the still lifes are not to be achieved safely in the studio but hazarded in dangerous country and against the possible obstacles of wind and glare and uncomfortable temperatures. Somehow we are to find quiet in risk and adversity.

Why are a table, a glass, a pitcher, and two apples worth our attention and even our reverence? Milosz addresses this question in a prayer that he offers on behalf of elderly women whose lives he imagines from old photographs. He prays that they died with hope, which he describes as "trust in the light that shines through earthly forms."[5]

1. Anne Porter, "House Lots," in *An Altogether Different Language* (Cambridge, Mass.: Zoland Books, 1994), 107.
2. Calvin Tomkins, "No More Boring Art: John Baldessari's Crusade," *New Yorker* (October 18, 2010).
3. Marilyn Berlin Snell, "The Art of Place: Interview with Wendell Berry," in *Conversations with Wendell Berry*, ed. Morris Allen Grubbs (Jackson: University Press of Mississippi, 2007), 54.
4. Czeslaw Milosz, "A Master of My Craft," in *Second Space* (New York: Harper Collins, 2004), 10.
5. Milosz, "Old Women," in ibid., 12.

Composed from notes made on the occasion of a retrospective exhibition at the
Yale University Art Gallery in 2012

I thank Kerstin for having shared with me her love of art.

And together we thank Jock Reynolds,
whose friendship has many times sustained us.